I can crayon

Ray Gibson

Designed by Amanda Barlow
Edited by Jenny Tyler
Illustrated by Amanda Barlow
and Michaela Kennard
Photography by Howard Allman

Contents

Little fat birds

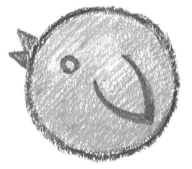

1. Crayon a fat body.

2. Fill in the shape. Add a beak.

3. Draw an eye nea the beak. Add a wing.

This bird is feeding a worm to her baby.

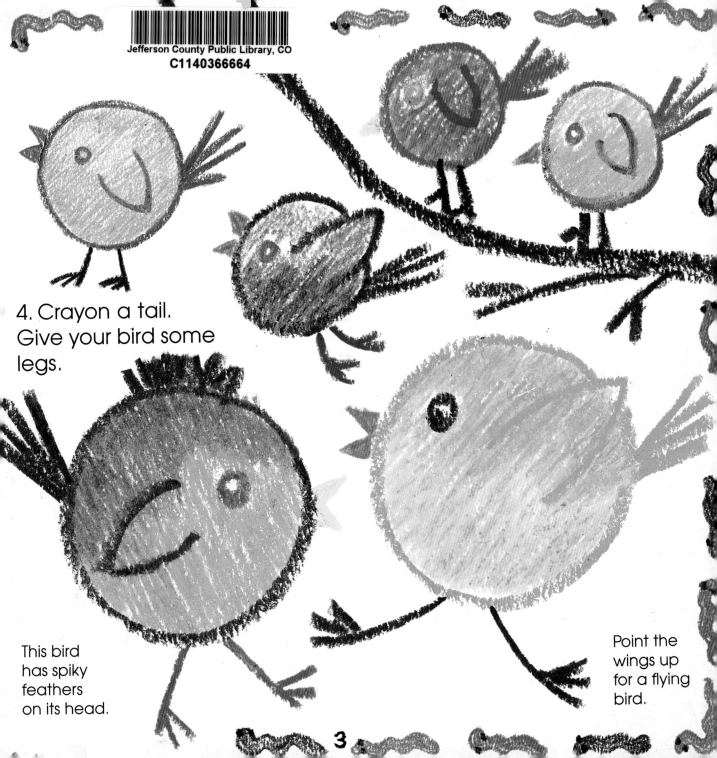

4. Crayon a tail. Give your bird some legs.

This bird has spiky feathers on its head.

Point the wings up for a flying bird.

3

Spiders in the dark

1. Crayon a fat body.

2. Add big eyes.

3. Crayon in the body.

4

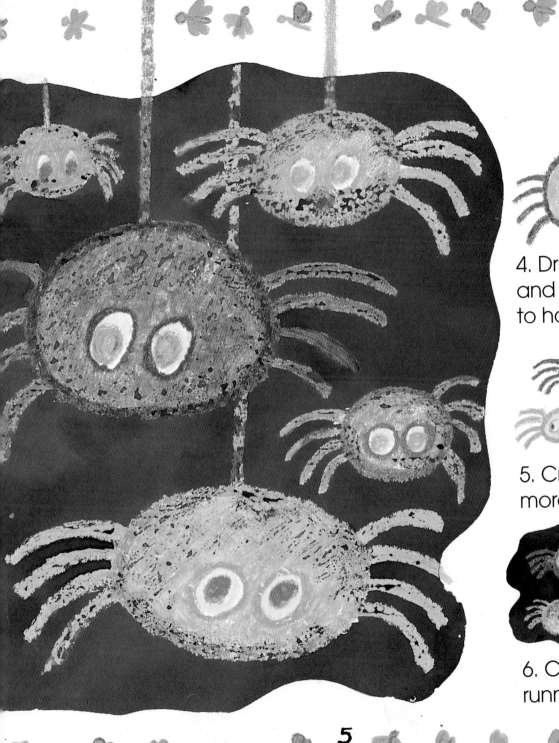

4. Draw 8 legs, and a thread to hang from.

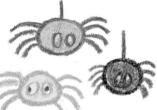

5. Crayon some more spiders.

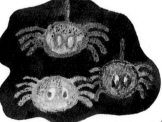

6. Cover with runny paint.

5

A big crane

1. Crayon the cab. Leave a window hole.

2. Crayon the lifting part.

3. Draw the cable.

You could add some stripes.

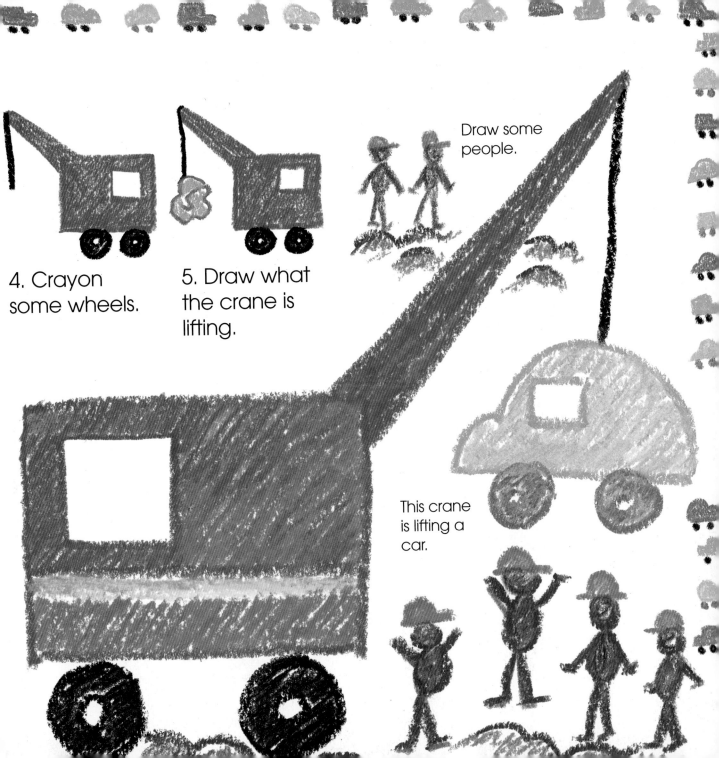

Draw some people.

4. Crayon some wheels.

5. Draw what the crane is lifting.

This crane is lifting a car.

A duck card

1. Cut off the corner of an envelope. Crayon the inside. Crayon the top.

2. Fold paper to make a card. Open it up again.

3. Glue the envelope corner in the middle. This makes a beak.

4. Lift the top up with a finger. Close the card. Squash flat.

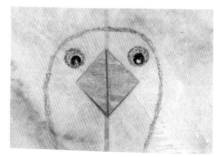

5. Open it up. Draw a duck's head around the beak. Draw some eyes.

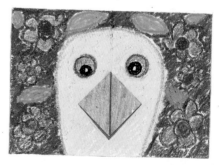

6. Crayon flowers and leaves around your duck.

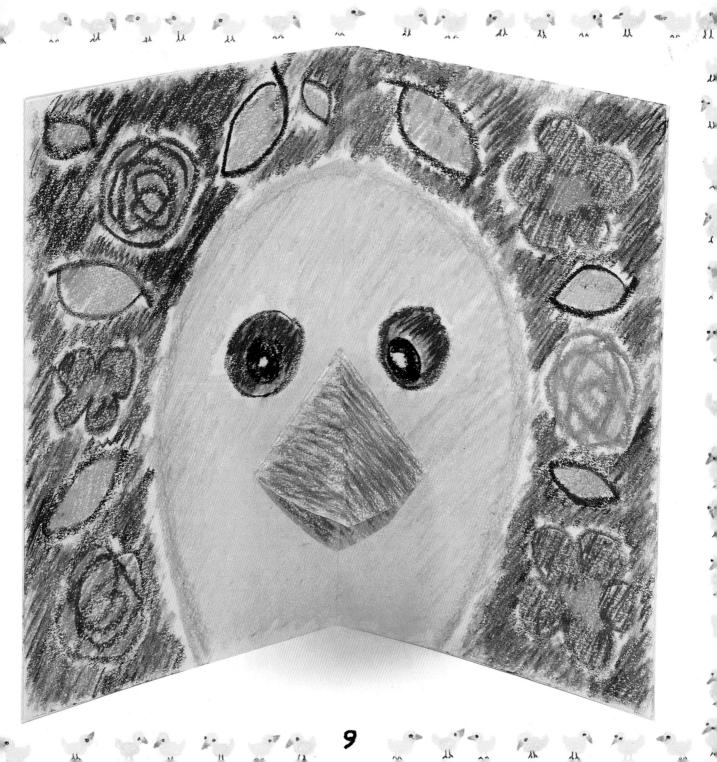

A flower picture

1. Cut a round shape from an old birthday card.

2. Glue it onto some paper.

3. Cut out petals. Glue them on.

4. Clip some paper on top.

5. Rub over the flower shape with bright crayons.

You can make some leaves too.

6. Move the paper. Make more flowers.

Fireworks

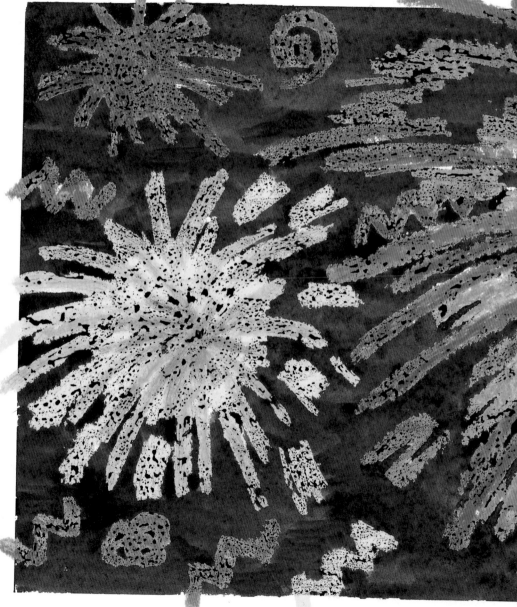

1. Crayon a big firework. Press hard.

2. Add lots of sparks and squiggles.

3. Paint all over with runny dark paint.

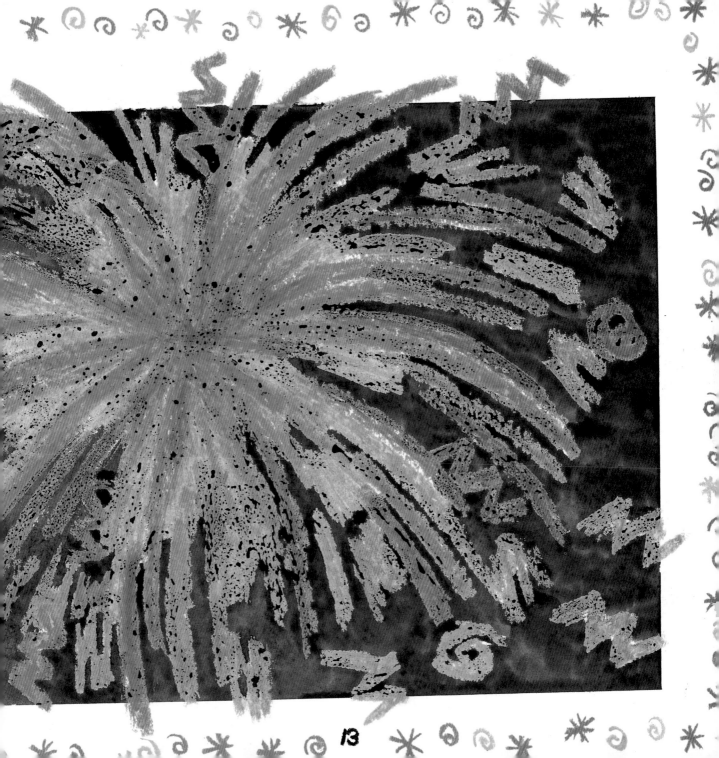

13

A tall giraffe

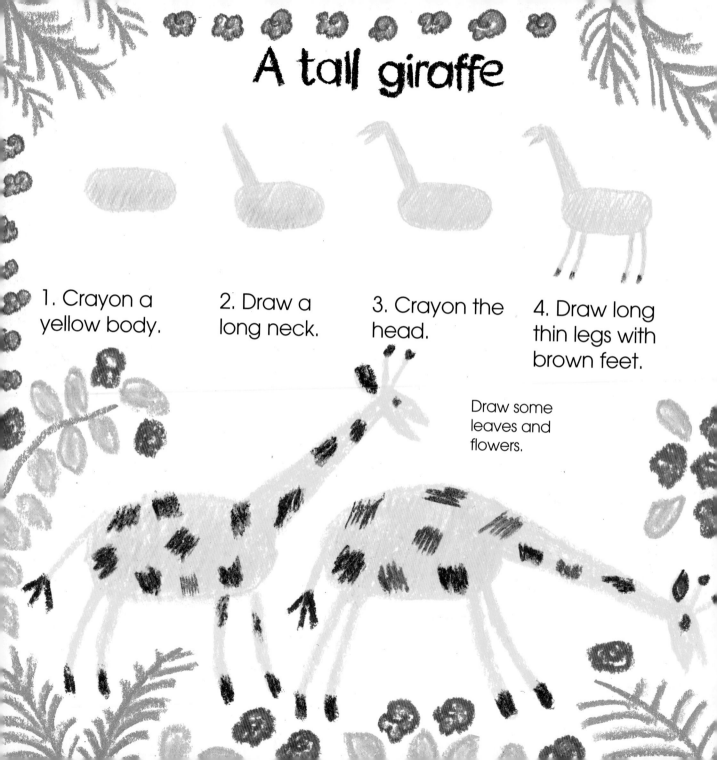

1. Crayon a yellow body.

2. Draw a long neck.

3. Crayon the head.

4. Draw long thin legs with brown feet.

Draw some leaves and flowers.

5. Add an ear
and two horns.

6. Put in an eye.
Add a tail, and
patches.

Loopy snakes

1. Crayon patterns and stripes all over strong thin paper.

You can overlap the snakes when you stick them down.

2. Cut the paper into strips - some fat, some thin.

3. Cut a thin point for a head. Cut a fat point for a tail.

4. Put glue under the head and tail.

5. Bend and stick onto paper.

6. Stick on eyes made from circles cut in half.

A fishy scene

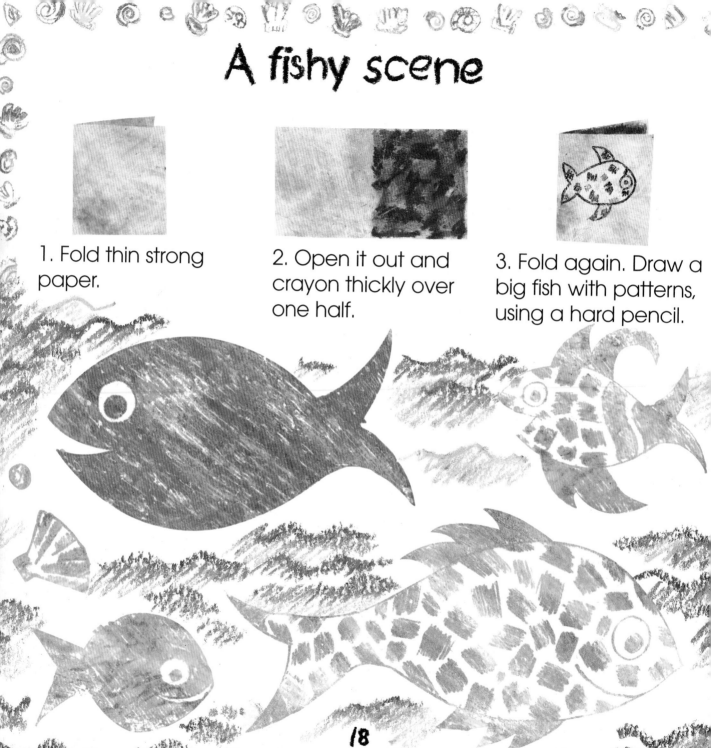

1. Fold thin strong paper.

2. Open it out and crayon thickly over one half.

3. Fold again. Draw a big fish with patterns, using a hard pencil.

18

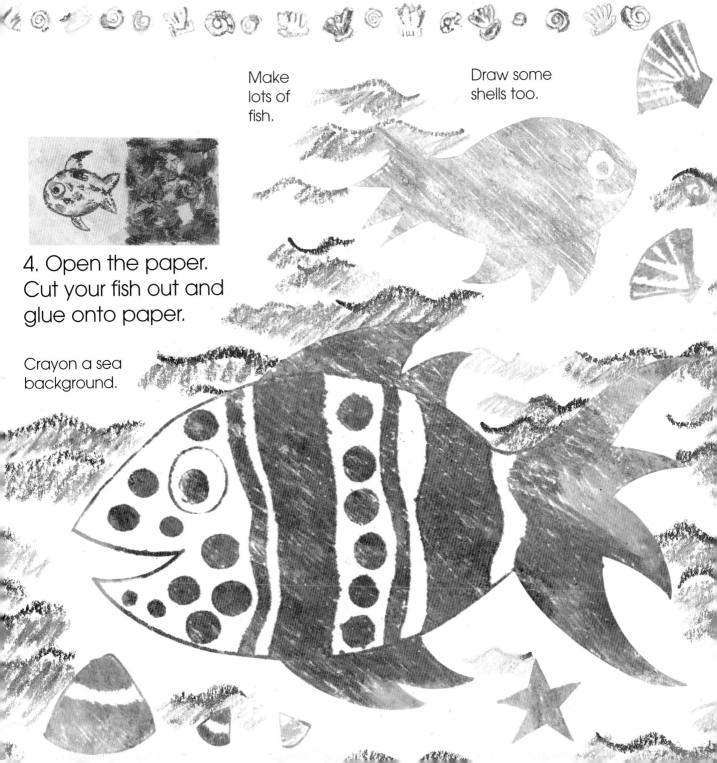

Make lots of fish.

Draw some shells too.

4. Open the paper. Cut your fish out and glue onto paper.

Crayon a sea background.

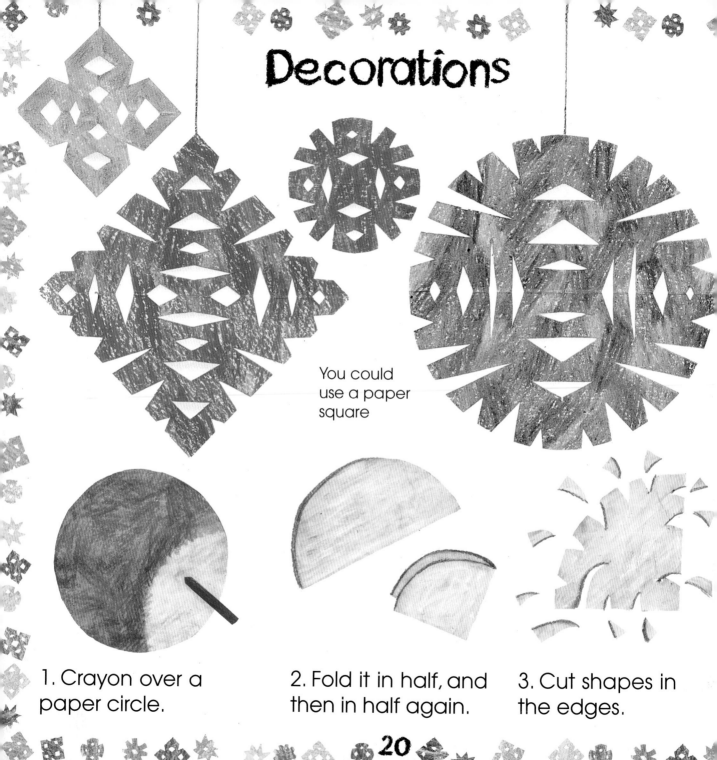

Decorations

You could
use a paper
square

1. Crayon over a
paper circle.

2. Fold it in half, and
then in half again.

3. Cut shapes in
the edges.

20

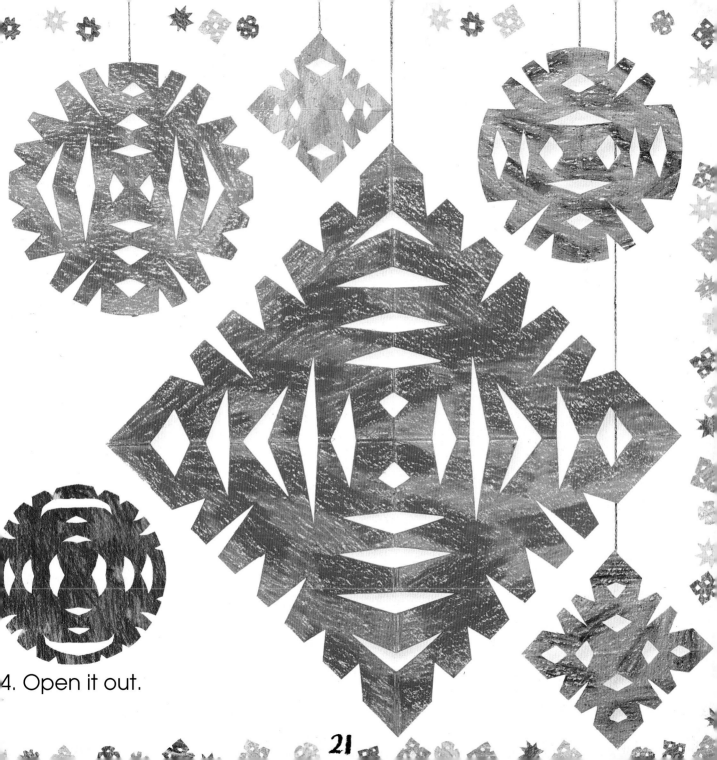

4. Open it out.

A caterpillar

1. Put a fat crayon on your paper, like this.

2. Push it up and down across the paper for a body.

3. Draw a head.

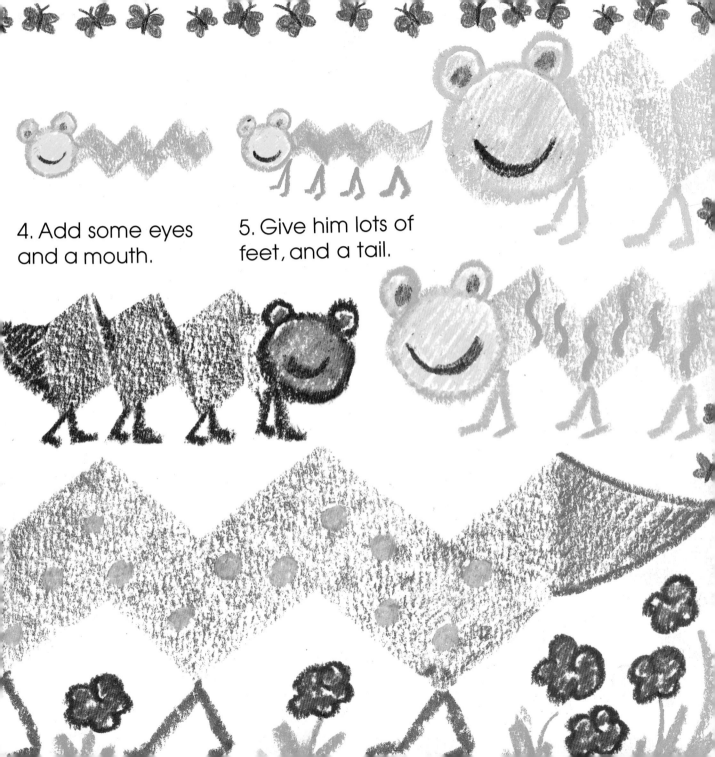

4. Add some eyes and a mouth.

5. Give him lots of feet, and a tail.

 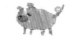

A piggy puppet

1. Stick down the flap of a long envelope. Cut it in two.

2. Fold in the corners of the open end.

3. Turn it over. Crayon the head. Add a snout.

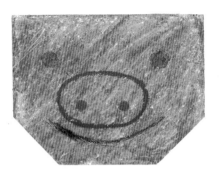

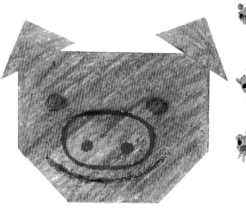

4. Draw two eyes, and a mouth.

5. Cut the corners from the closed end of the other piece.

6. Crayon them. Glue them on.

Add big round ears for a mouse.

Add big eyes for a frog.

Big trucks

1. Find an envelope or cut a rectangle.

2. Crayon patterns all over.

3. Paint with runny paint. Let it dry.

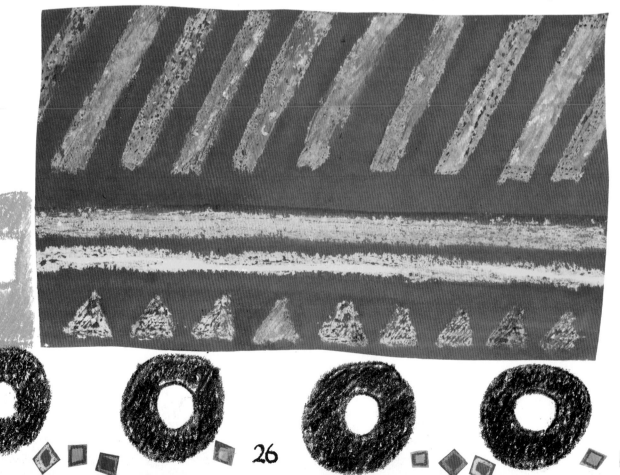

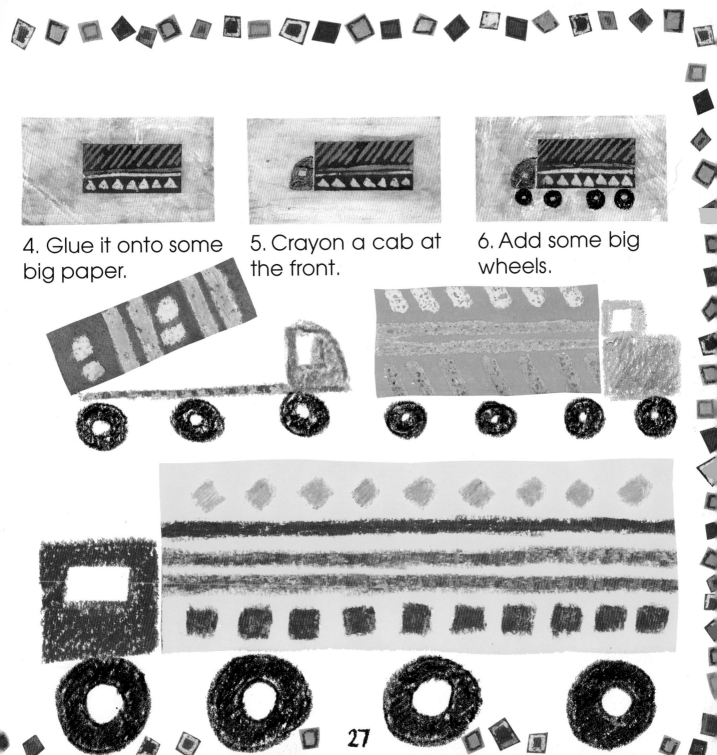

4. Glue it onto some big paper.

5. Crayon a cab at the front.

6. Add some big wheels.

Decorated eggs

1. Hard boil an egg. Crayon patterns on it.

2. Put some drops of food dye in a small bowl.

3. Put the egg in. Dab the dye all over with a paintbrush.

4. Lift it out with a spoon. Put it on paper towel to dry.

You can eat your egg if you like.

5. Put some cooking oil in a saucer.

6. Dip paper towel in the oil. Rub over the egg to make it shine.

A butterfly

1. Fold a piece of strong thin paper. Open it out.

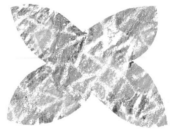

2. Cut a card into pieces. Glue close together on one side.

3. Fold the paper again. Crayon over the top.

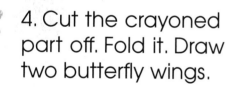

4. Cut the crayoned part off. Fold it. Draw two butterfly wings.

5. Cut out the wings. Open them out.

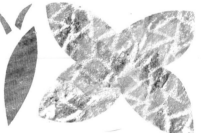

6. Crayon feelers and a body. Cut out and glue on.

30

Make some
leaves from
the leftovers,
or crayon
some more.

Lots of shapes

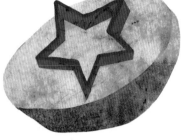 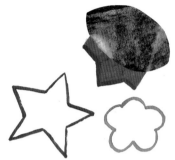

1. Ask a grown-up to press the sharp side of a cookie cutter into half a potato.

2. Pour some paint on an old cloth or newspaper.

3. Press the cutter in the paint and then onto some paper.

4. Make more shapes. Let them dry. Crayon them.